I WANT TO BE A MACHINE

ANDY WARHOL &
EDUARDO
PAOLOZZI

National
Galleries
of Scotland
2018

Keith Hartley

This catalogue has been published to accompany two parallel displays of the work of Andy Warhol and Eduardo Paolozzi at the Scottish National Gallery of Modern Art; designed to show the remarkable similarities – as well as differences – between these two artists, one American, the other Scottish, observable from early beginnings in the 1940s and through their respective careers. Both understood that the post-war world was being shaped at break-neck speed by the machine and that the best means of capturing that reality was by adopting a mechanised approach. This meant the use of photographic images and translating those images mechanically into art. Both artists turned to photo-screenprinting at roughly the same time in the early 1960s.

The National Galleries of Scotland's ability to do this rich subject justice is only possible because of the collections of work by both artists that were bequeathed to us, that have been given or been bought over the years: the Warhols are (except for those generously lent by Tate) part of the ARTIST ROOMS collection that we share with Tate and which was established through The d'Offay Donation in 2008, with the assistance of the National Heritage Memorial Fund, Art Fund, and the Scottish and British Governments. Many of the works by Paolozzi were bequeathed to us by Gabrielle Keiller, given by Paolozzi himself or acquired by us in the knowledge that he was one of Scotland's most important artists.

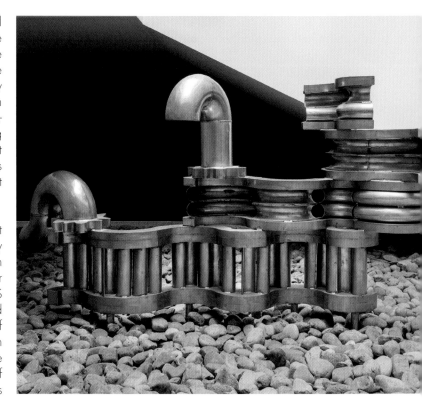

Sir John Leighton
Director-General, National
Galleries of Scotland

Dr Simon Groom
Director, Modern and
Contemporary Art, National
Galleries of Scotland

ANDY WARHOL & EDUARDO PAOLOZZI

I WANT TO BE A MACHINE

In the summer of 1968 the Art Advisory Service of the Museum of Modern Art in New York organised an exhibition of five artists in the lobby of the famous Four Seasons restaurant at 99 East 52nd Street.[1] Included in the five were Andy Warhol and Eduardo Paolozzi. Warhol was represented in the show by six of his silkscreen prints of Marilyn Monroe produced in the previous year.[2] As the press release says: 'This particular image is one he has used many times before, but never more successfully than in these newest works … Viewed together, the varied range of expression is remarkably striking. Dramatic shifts in color as well as character are achieved in each separate screen.' Paolozzi was represented by a highly polished aluminium sculpture *Marok-Marok-Miosa*, 1965 (fig.1), 'mirroring its surroundings', and two 'brilliantly colored silkscreen prints done this year and closely related to his sculpture'.[3]

Marok-Marok-Miosa consists of a series of aluminium parts, welded together to form a winding group of figures, with snake-like pipes emerging from them – probably inspired by the famous ancient Graeco-Roman sculpture *Laocoön* (now in the Vatican Museums in Rome), which fascinated Paolozzi at this particular time. The synthesis of classical sculpture with machine-made, serial metal structures goes back in Paolozzi's work

to his earliest paper collages in 1946, when he was only twenty-two years old. The two brightly coloured prints which mirrored the shapes of the sculpture were from *Universal Electronic Vacuum*, a portfolio of ten screenprints that evidences the beginnings of Paolozzi's interest in the relatively new imagery emerging from computer print-outs – the latest metamorphosis of the machine. Working with the master printer Chris Prater in Kelpra Studio, London, Paolozzi was one of the first artists to exploit the full potential of screenprinting: beginning with a photographic image that was transferred onto the screen, but then proceeding to use a whole series of successive screens to print a range of colours. In 1963 he had taken advantage of the relative ease of changing the colours by printing each of the forty-sheet run of the key screenprint *Metalization of a Dream* (figs 2, 3) with a different colourway. What Paolozzi was doing in screenprinting was a parallel exploitation of the mechanical processes inherent in the medium to the way that he used prefabricated metal parts to make sculptures.

At the same time, on the other side of the Atlantic, Warhol was carrying out similar experiments with mechanical processes, so as to exploit the full potential of photography and colour. The set of *Marilyn Monroe* screenprints (six instead of the full ten) shown in the exhibition

Figure 1
Eduardo Paolozzi (1924–2005)
Marok-Marok-Miosa, 1965
Welded aluminium
150 × 290 × 110 cm
The John B. Putnam Memorial Collection,
Princeton University
y1969-21

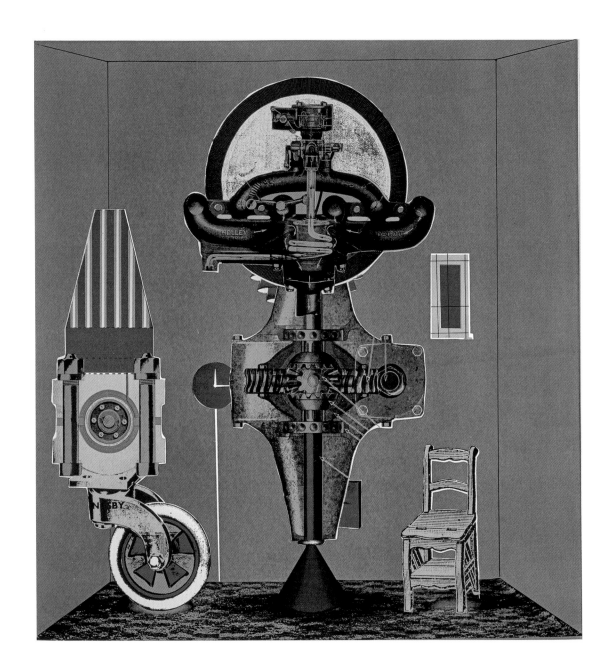

I WANT TO BE A MACHINE

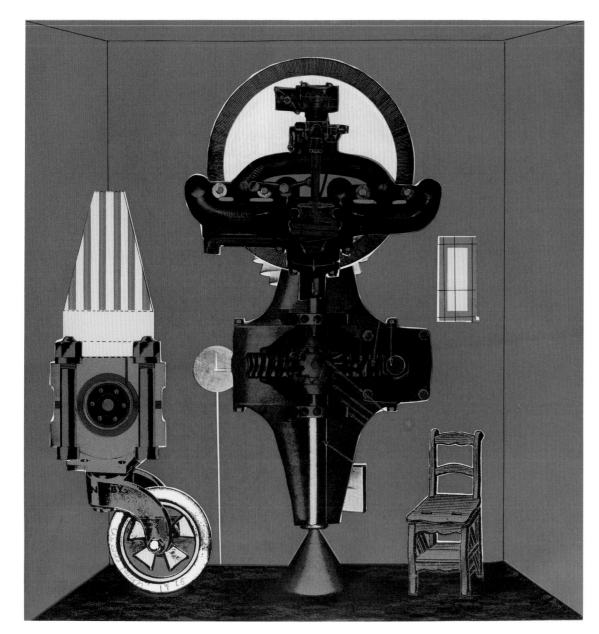

Figure 2
Eduardo Paolozzi (1924–2005)
Metalization of a Dream, 1963
Screenprint on paper, 59.5 × 54.4 cm
National Galleries of Scotland; bequeathed by
Gabrielle Keiller, 1995
GMA 4046

Figure 3
Eduardo Paolozzi (1924–2005)
Metalization of a Dream, 1963
Screenprint on paper, 59.5 × 54.4 cm
Hunterian Art Gallery, University of Glasgow
GLAHA 51101

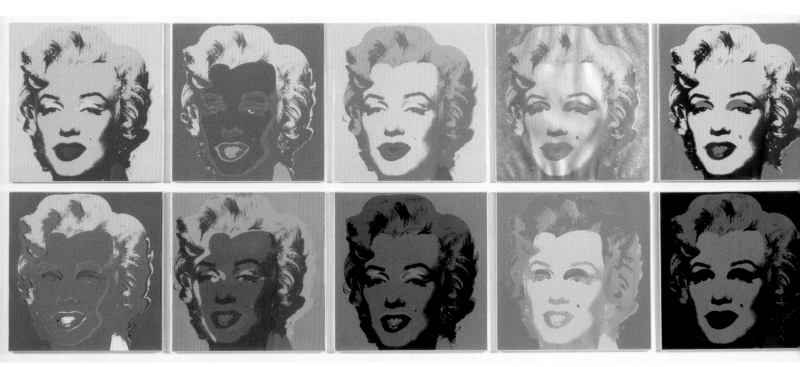

at the Four Seasons were also printed in different colour combinations **(fig.4)**. Although the photographic image remained the same, the changing colours made her features look different and certainly seemed to alter her expression. While Warhol made this kaleidoscopic series in 1967, a full four years after Paolozzi rang the colour changes in *Metalization of a Dream*, there is a fundamental difference in the two print productions. Paolozzi never intended to show all the differently coloured prints together. In a way, it enabled him to turn an inherently serial production of near-identical prints into unique works of art. The mechanical process of photo-screenprinting allowed him to do this with relative ease. Warhol, on the other hand, made

the set of *Marilyn* prints with the express purpose of them being shown together. Each individual print was differently coloured, but each set was identical. In a way it was like the *Campbell's Soup Can* series. The basic shape and structure were the same – like Marilyn's head – but each print showed a different can of soup **(fig.5)**. The point was that each can of black bean, each can of tomato, tasted the same. There was uniformity within variety. And Warhol liked that. He felt that it was very democratic and very American.

Warhol's 'discovery' of screenprinting in the summer of 1962 (probably around the same time as Robert Rauschenberg (1925–2008)) allowed

Figure 4
Andy Warhol (1928–1987)
'Marilyn' [no title], 1967
Ten prints, each screenprint on paper, 91 × 91 cm
Tate; purchased 1971
P07121

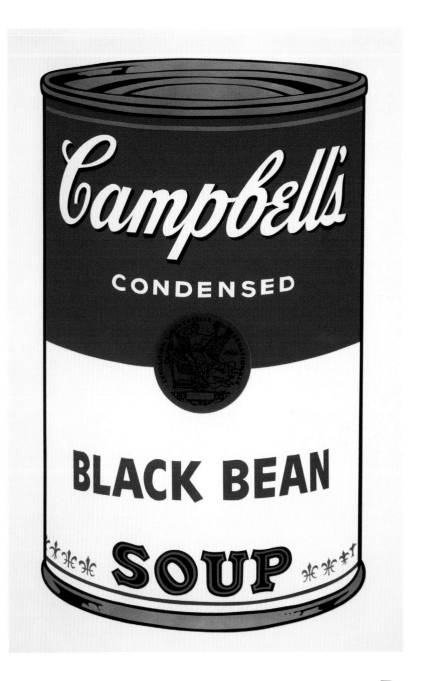

him to use photographs as the direct basis for his paintings, without the need to trace and enlarge or project and copy the images. The process was as near to the mechanisation of art as it was possible to get at that time and Warhol was very aware of this. In a key interview given to Gene R. Swenson in 1963, he talks about the anonymous, mechanical nature of screenprinting paintings:

> That's … one reason I'm using silk screens now. I think somebody should be able to do all my paintings for me. … I think it would be so great if more people took up silk screens so that no one would know whether my picture was mine or some-body else's … The reason I'm painting this way is that I want to be a machine, and I feel that whatever I do and do machine-like is what I want to do.[4]

Warhol's laconic style of public pronouncements – later often reduced to a mere 'yes', 'no' or 'uh-uh' – is usually seen as part and parcel of his desire to be a machine, a sort of automaton with no feelings, no spontaneous deviation from a pre-programmed response: a public façade to avoid having to engage in public debate. But, in fact, it was much more serious and considered than that. Back in the late 1940s, when he was studying art and design at the Carnegie Institute

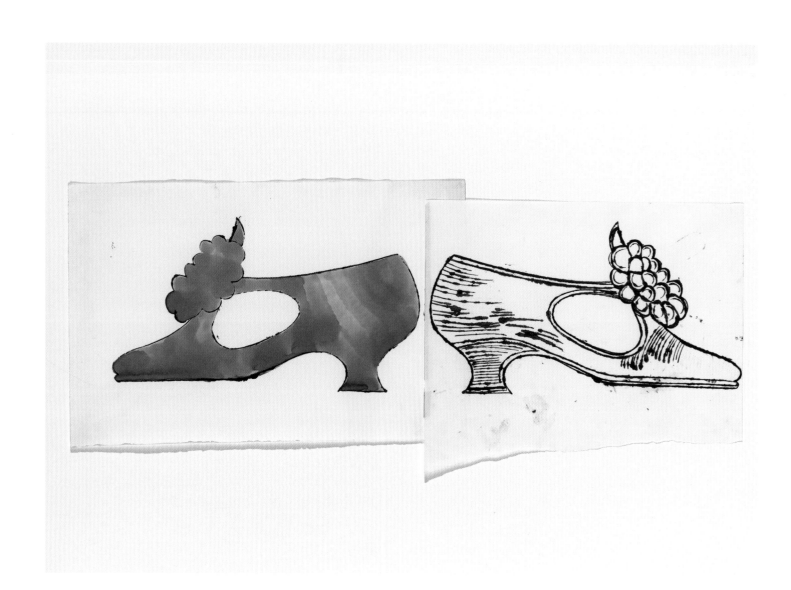

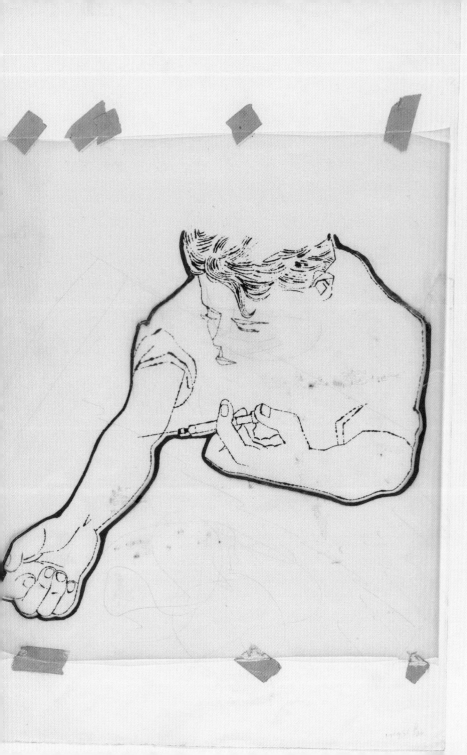

Figure 6
Andy Warhol (1928–1987)
Blue Shoe, 1955
Ink and dye on paper, 32.7 × 97 cm
ARTIST ROOMS National Galleries of Scotland and Tate; acquired jointly through
The d'Offay Donation with assistance from the National Heritage Memorial Fund
and the Art Fund, 2008
AR00251

Figure 7
Andy Warhol (1928–1987)
The Nation's Nightmare, 1951
Ink, graphite and acetate on paper, 51 × 41 cm
ARTIST ROOMS National Galleries of Scotland and Tate; acquired jointly through
The d'Offay Donation with assistance from the National Heritage Memorial Fund
and the Art Fund, 2008
AR00240

Figure 8
Andy Warhol (1928—1987)
Head of a Girl and Children, 1958—61
Graphite and gouache on paper, 73.5 × 58 cm
ARTIST ROOMS National Galleries of Scotland and
Tate; acquired jointly through The d'Offay Donation
with assistance from the National Heritage
Memorial Fund and the Art Fund, 2008
AR00282

of Technology in Pittsburgh, he had been fascinated by the ideas of industrial design and mechanised production coming out of the Bauhaus (first in Germany and then, from 1937 onwards, in Chicago, where the famous art school had been reborn).

The machine as a symbol of modernism was neatly encapsulated in the term 'machine age'. The expression was in wide use by 1927 and has since described the period from the late nineteenth century to the Second World War, when an increasingly large proportion of manufactured products were made by machines rather than crafted by hand. Artists and architects responded to this variously. Those who welcomed it unreservedly included the Futurists in Italy and the Vorticists in Britain, Fernand Léger (1881–1955) and the Purists in France, the Precisionists in the USA and the Bauhaus in Germany. It was perhaps the Bauhaus as an art school that had the biggest impact in America, with its well-planned structure and courses aimed at training artists, designers and architects to develop art forms and products that could be made using mechanised production methods, without the need for hand-crafted ornaments. Alfred Barr, the

director of the fledgling Museum of Modern Art, was an enthusiastic convert to Bauhaus ideas and put on major exhibitions, not only on the Bauhaus itself (in 1938–39) but on 'Machine Art' as well (in 1934), a show which was given over to factory-made products and gloried in stripped-down functionalism and gleaming stainless steel.[5]

Warhol wholeheartedly endorsed the view that modern industrial society needed to accept the mechanised processes that made modern society function. In particular, he was drawn to what László Moholy-Nagy (1895–1946), the founder of the 'New Bauhaus' (later called the Institute of Design of the Illinois Institute of Technology) in Chicago, had to say about the vital role that photography and photo-mechanical processes had to play in contemporary art. In his rigorously argued Bauhaus book *Painting, Photography, Film* (1925), Moholy-Nagy contends that photographic ways of representing reality should be used in painting:

> *We cannot therefore express hostility towards representational art but must demand that in conformity with our interest in and feeling for*

the world at large, up-to-date consequences are drawn: that painterly methods of representation suggestive merely of past times and past ideologies shall disappear and their place be taken by **mechanical means of representation** *and their as yet unpredictable* **possibilities of extension**.[6]

What Moholy-Nagy emphasises in this passage is prophetic. Not only does it look forward to such developments as photo-screenprinting, but it must have helped foster the medium's development through Warhol's enthusiastic response to Moholy-Nagy's ideas, which helped persuade Warhol that figurative art now had to use the unparalleled visual accuracy and detailed information that photography could provide.

One straightforward way to make use of this photographic information was to trace the outlines of figures through transparent paper. Warhol had already done this as a child, using comics and photographs of Hollywood stars; but when he attended the Carnegie Institute of Technology – and especially when he drew items for the

student magazine *Cano* – he learned how to use stored, traced outlines to make further drawings. He would use a pen to go over the pencil outlines and then press the still-wet redrawn image onto another piece of paper. He may have learned how to do this from seeing similar line drawings by the American artist Ben Shahn (1898–1969). This technique was, in effect, a very simple form of printmaking, of creating a monoprint. Warhol referred to it as his 'blotted-line' technique – so called because after impressing the image onto one piece of paper, there was little ink left on the 'original' to make another print (fig.6). As well as producing a ghost-like image of the first drawing, an image with the light-hearted, whimsical quality that Warhol liked, the 'blotted-line' technique enabled the artist to create a bank of images (usually of figures) to reuse at will. Sometimes he would use only part of a figure (as in overlaps), sometimes he would use a mirror image of the figure by inking the reverse of the tracing. When he came to rely on the 'blotted-line' technique on a regular basis for his commercial work in New York in the 1950s (fig.7), Warhol even created a tongue-in-cheek 'alphabet' of the human types he had in his bank of images. He called the home-made promotional book of these types *A is an Alphabet* (1953).[7] If one compares the figures in the alphabet with the figures drawn for his advertisements and magazine and book cover designs, one finds many of them used again and again, often in very different contexts. In fact, most of these figure drawings were traced from photographic illustrations in his favourite magazines – particularly *LIFE*. Sometimes he would use photographs made by friends, such as Edward Wallowitch (1932–1981), who specialised in capturing street kids playing around in New York or posing for the camera. Warhol traced part of such a grouping of children on a sidewalk and, together with another tracing, created the complex drawing *Head of Girl and Children, c.*1958–61 (fig.8).

Although Warhol did not give up his commercial work (figs 9, 10) – in fact, he carried on accepting commissions for poster and magazine designs until 1987, shortly before his death – in 1960 he decided to develop his career as an independent artist by starting to make paintings. The crucial thing is that he still depended on using found images. At first these were based on comic-strip characters, such as Dick Tracy, Popeye and Superman, but, eying the competition in this area from Roy Lichtenstein (1923–1997), he soon moved on to using images taken from advertisements, popular consumer products and eventually film celebrities, such as Marilyn Monroe, Elvis Presley and Elizabeth Taylor. Initially Warhol would project images of

Figure 9
Andy Warhol (1928–1987)
Absolut Vodka, 1985
Offset lithograph on paper, 114.5 × 94.1 cm
ARTIST ROOMS National Galleries of Scotland and Tate; acquired jointly through The d'Offay Donation with assistance from the National Heritage Memorial Fund and the Art Fund, 2008
AR00391

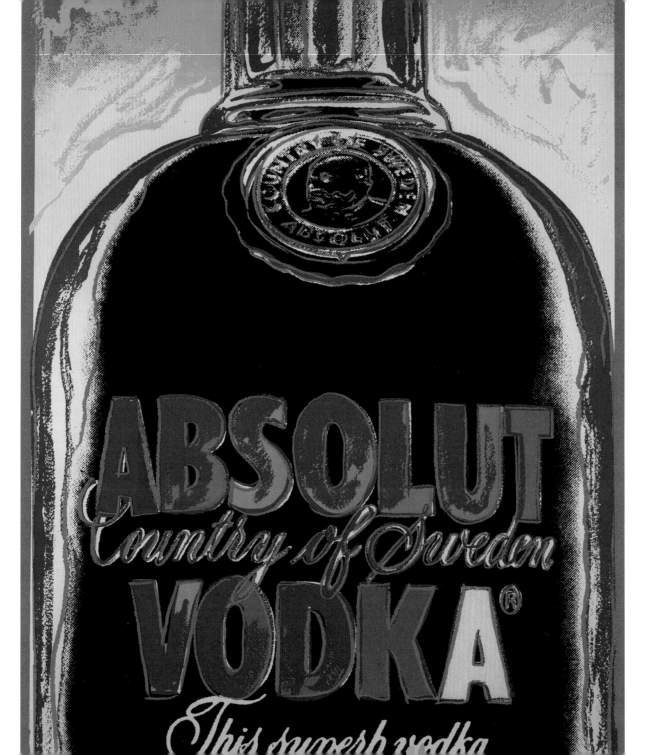

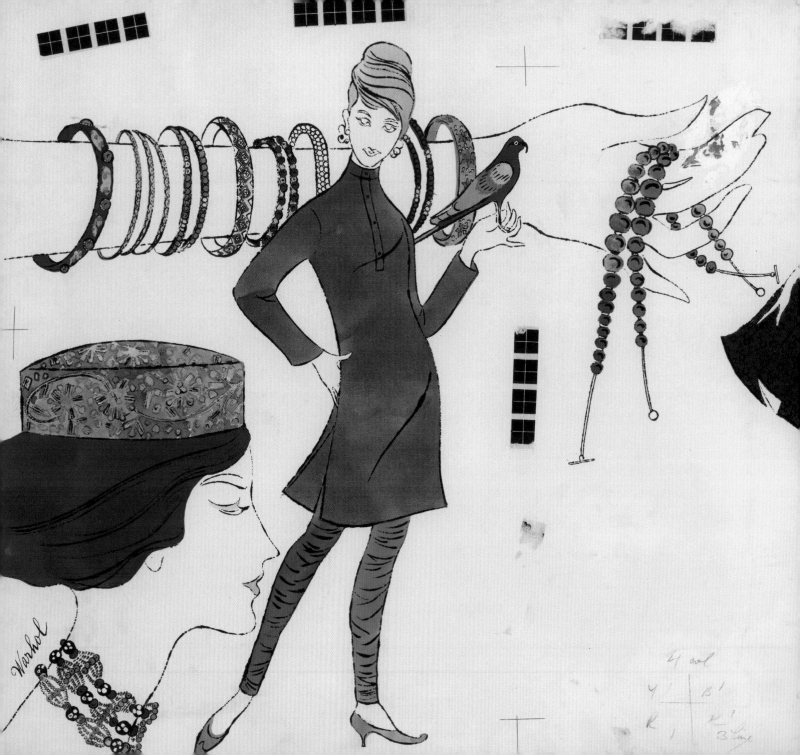

Figure 10
Andy Warhol (1928–1987)
Female Figures and Fashion Accessories, 1959
Ink, printed paper and dye on paper on board, 43 × 62.8 cm
ARTIST ROOMS National Galleries of Scotland and Tate; acquired jointly
through The d'Offay Donation with assistance from the National Heritage
Memorial Fund and the Art Fund, 2008
AR00285
Commissioned by *Mademoiselle* magazine; appeared as 'Treasures from
India', issue 259, December 1959, pp.50–51.

what he wanted to paint onto his canvas and
trace out the main lines of his subject. When he
wanted to make serial images of the same every-
day object, such as green stamps or dollar bills,
he would make rubber stamps. This semi-mech-
anised process was an important intermediate
step before he realised that he could simply
use the photographic image itself as the basis
of a screenprint.

Screenprinting had been used for some time
in the American commercial world, and
had been dubbed 'serigraphy' for greater
respectability when taken up by artists supported
by the Federal Arts Project during the 1930s
Depression, but very few artists used it to
reproduce photographic images – at least not
without making considerable marks of their own
to give the prints 'authenticity'. With the rise of
what was initially called a new form of realism
– and later called Pop Art – it was perhaps
only a matter of time before artists would come
to the conclusion that screenprinting presented
them with the ideal way of appropriating
photographic images of the consumer
world about them. In Britain, Paolozzi was
one of a number of artists who worked with
Chris Prater to make screenprints in the early
1960s. In the US Warhol and Rauschenberg
were among the first to realise the potential of

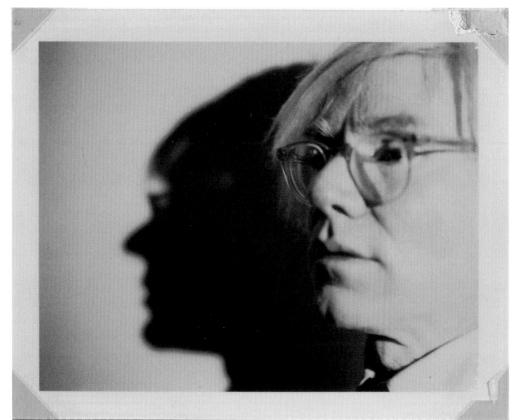

Figure 11
Andy Warhol (1928–1987)
Self-portrait in Profile with Shadow, 1981
Photograph, colour Polaroid, on paper, 7.2 × 9.5 cm
ARTIST ROOMS National Galleries of Scotland and
Tate; acquired jointly through The d'Offay Donation
with assistance from the National Heritage
Memorial Fund and the Art Fund, 2008
AR00311

photo-screenprinting in their art. For Warhol this was a decisive step. The image, provided by the photographic template, could be screenprinted directly onto the canvas – or, in the case of prints, onto the paper – usually last of all. The colours, if there were any, were applied separately and, if need be, set free from any representational linkage. Warhol made ample and creative use of this decoupling of black-and-white image and colour. It enabled him to ring the changes in decorative and expressive effect that different colours allowed, while still maintaining a stable image. In some cases (and as early as 1963), Warhol took this separation to its logical conclusion and produced diptychs in which the image was depicted on one of the panels and the other panel was painted with pure, unbroken colour. Thus, Moholy-Nagy's prediction in *Painting, Photography, Film* was to come true: 'the discussion about objective and non-objective *painting* will cease to be important; the whole problem will have to be comprised in **absolute** and (not 'or' but **and**) **representational** optical *creation*.'[8]

Figure 12
Andy Warhol (1928–1987)
The Shadow, 1981
Graphite on paper, 80 × 61 cm
ARTIST ROOMS National Galleries of Scotland and
Tate; acquired jointly through The d'Offay Donation
with assistance from the National Heritage
Memorial Fund and the Art Fund, 2008
AR00594

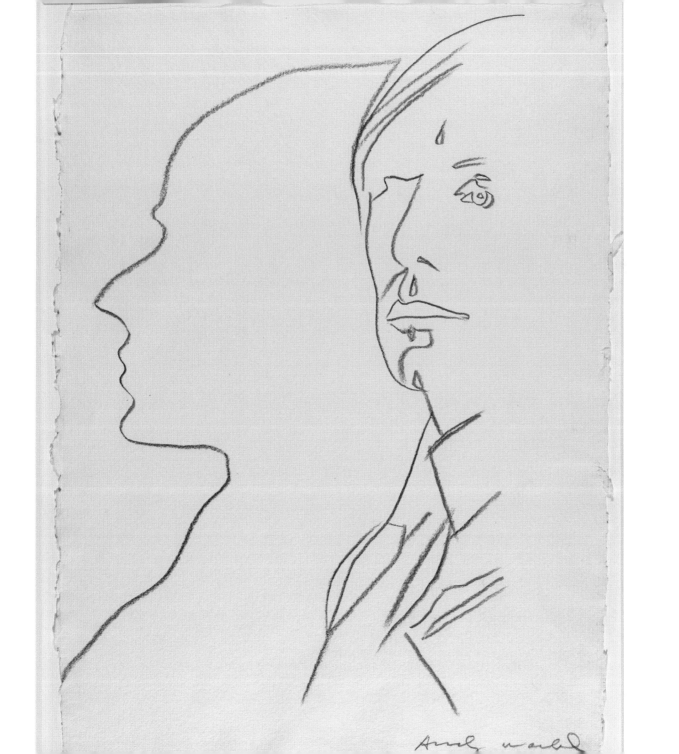

Warhol's understanding of the machine and its interface with the artist (and, most importantly, himself) was really concerned with artistic process and conceptual underpinning. Like one of his artistic idols, Marcel Duchamp (1887–1968), Warhol sought the cool objectivity of the machine and was never afraid of taking things to their logical conclusion. If the lens of the camera gave one an unbiased scrutiny of outside reality, then the lens of the film camera would extend that scrutiny into the dimension of time, capturing the minutest changes in the figure or object it is trained on. The logic is unimpeachable; and so Warhol set up his film camera in front of a sleeping friend for eight hours (*Sleep*, 1963) and, even more audaciously, trained it on the Empire State Building for twenty-four hours (*Empire*, 1964). In these and several other static-camera films, Warhol was not concerned with the traditional aspects of filmmaking – plot, character, action – but solely with film in its essence, using the camera purely as a machine for taking sequential images.

Warhol enjoyed having machines that recorded the ambient world – camera, Polaroid camera and tape recorder – with him at all times. He would use his camera to photograph not only people he met, but quirky things that caught his highly alert attention. He took thousands and thousands of photographs. The Polaroid photographs were mostly taken with a view to making portrait paintings (mainly in the 1970s – **figs 11, 12**): some of them, because he *wanted* to paint their portrait, but increasingly because the rich and the famous wanted to commission Warhol to give them social immortality. Although Warhol did exhibit some of his photographs in the 1980s, it was really only towards the end of his life that he found a way of using some of his black-and-white photographs to maximum effect. He selected certain key images, had multiple copies of them developed (sometimes identical copies, but sometimes varying how light or dark they were printed) and finally had them stitched together, usually in multiples of four, six or nine. In each case the threads were left dangling from the group of photographs, giving them a homespun look, but, at the same time, making clear to everyone that they had been joined together by a machine – a sewing machine. These 'stitched photographs', as they were known, recall the serial imagery of Warhol's paintings and prints of the 1960s, but make it very evident that the composite works are now made up of photographs. If his earlier paintings were based on photographic images, these were subjected to varying painting processes. Now, Warhol is, literally, letting it all hang out – threads and all – and making it perfectly clear to everyone

Figure 13
Andy Warhol (1928–1987)
Self-portrait, 1976/86
Six photographs, gelatine silver print on paper and thread, 69.8 × 80.4 cm
ARTIST ROOMS National Galleries of Scotland and Tate; acquired jointly through The d'Offay Donation with assistance from the National Heritage Memorial Fund and the Art Fund, 2008
AR00286

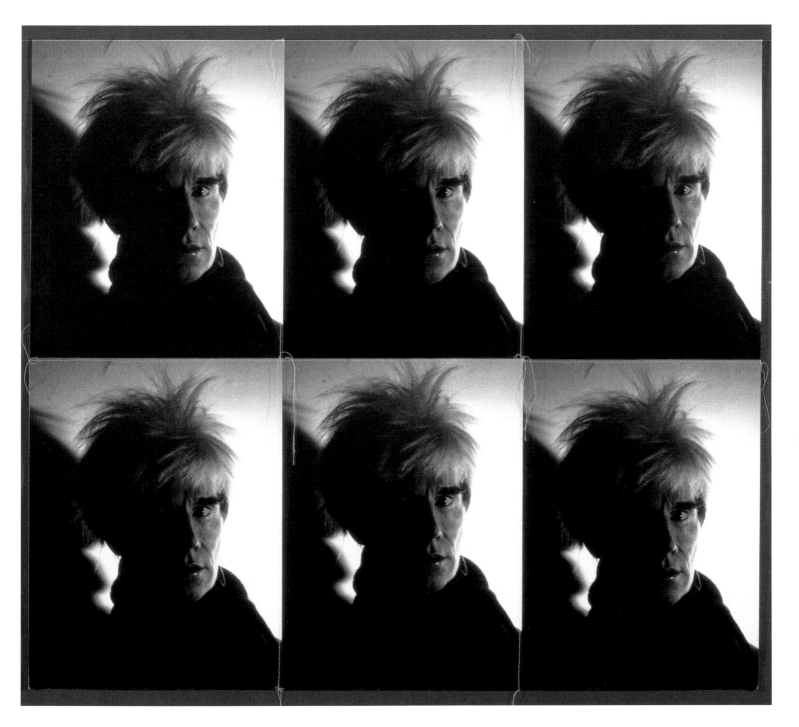

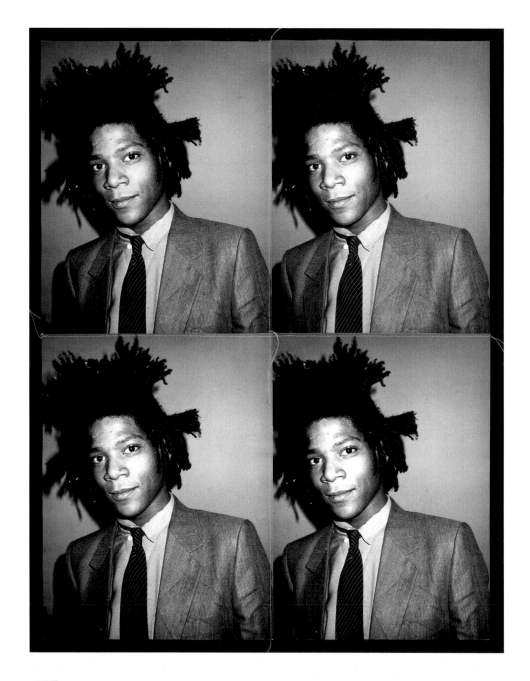

Figure 14
Andy Warhol (1928–1987)
Jean-Michel Basquiat, 1976/86, stitched 2014
Four photographs, gelatine silver print on paper and
thread, 69.4 × 54 cm
ARTIST ROOMS National Galleries of Scotland and
Tate; presented by The Andy Warhol Foundation for
the Visual Arts, 2016
AR01257

Figure 15
Eduardo Paolozzi (1924–2005)
Athena Lemnia von Phidias, 1953
Collage on book illustration, 26 × 18.7 cm
National Galleries of Scotland; bequeathed by
Gabrielle Keiller, 1995
GMA 4033

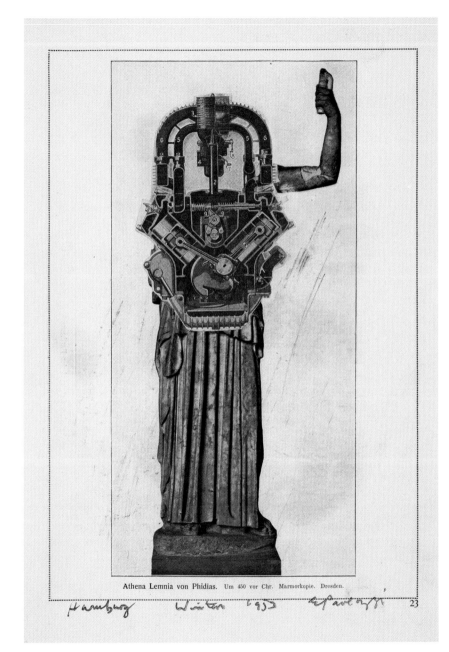

Athena Lemnia von Phidias. Um 450 vor Chr. Marmorkopie. Dresden.

Hamburg *Winter* '953 *E. Paolozzi* 23

that the images are one and the same, are multiples and the product of a mechanical process **(figs 13, 14)**.

Paolozzi's relationship with the machine was less conceptual than Warhol's: more direct and more visceral. He liked the way that machines worked; he liked how they fitted together; he liked how they made the modern world function. He saw physical analogies between humans and the machine and was fascinated by robots and the idea of robotic men. During the Second World War he came across a copy of Amédée Ozenfant's book *The Foundations of Modern Art* (English edition, 1931) and was fascinated by the way that Ozenfant (1886–1966) illustrated modern machinery alongside ancient works of art. Ozenfant saw them all in one continuum and did not separate off the modern world from what had gone before. A few years later Paolozzi was himself making collages that juxtaposed classical sculptures with the cogs, wheels, engines and electrical circuits of our modern world **(fig.15)**. This elision of the 'timeless' quality of the ancient world with the break-neck developments of the modern became a leitmotif in Paolozzi's work. He was fascinated by the constant evolution of new machines but he refused to set them on a pedestal and make them into a fetish.

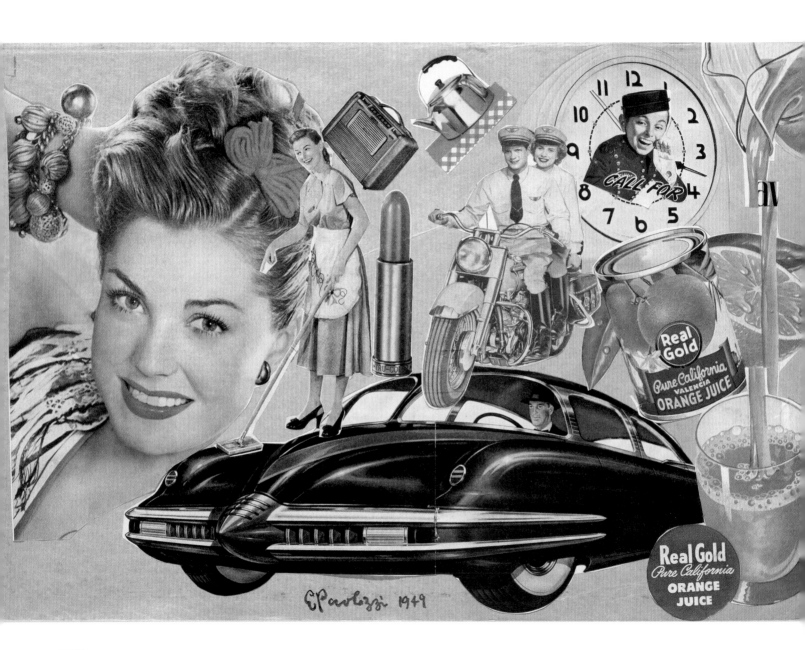

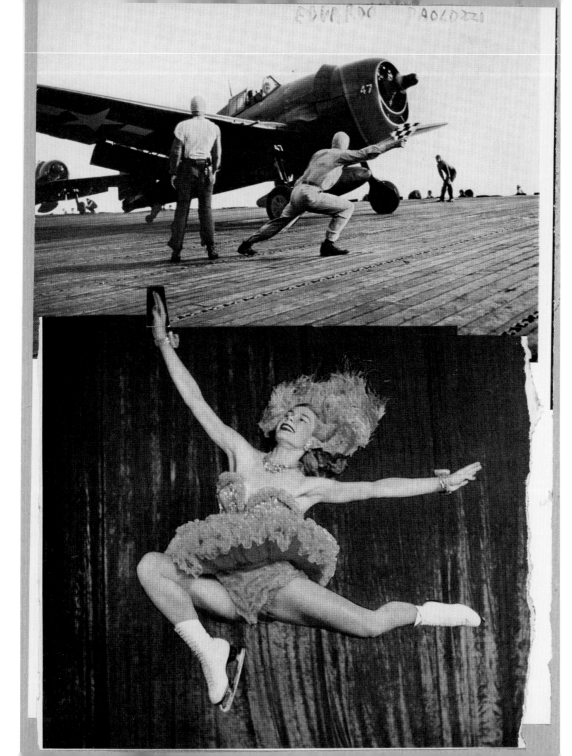

Figure 16
Eduardo Paolozzi (1924–2005)
Real Gold, 1949
Printed papers on paper
28.2 × 41.0 cm
Tate; presented by the artist, 1995
T06934

Figure 17
Eduardo Paolozzi (1924–2005)
Take Off, 1950
Printed papers on paper, 34.2 x 23.6 cm
National Galleries of Scotland; presented by the
artist, 1995
GMA A40.3/33

The nearest that Paolozzi came in his work to a celebration of modern life was in the collages he made in the late 1940s and early 1950s of American consumer products and popular culture: cars, Coca-Cola, hot dogs, the latest electronic gadgets and Hollywood stars. He had found these images of a prosperous post-war America in glossy magazines that he picked up from GIs and their girlfriends in Paris during his stay there from 1947 to 1949 **(figs 16, 17)**. These collages have little of the spirit of contrast or dada and surrealist iconoclasm found in much of his other contemporary work. To someone used to the deprivations of drab, ration-book Britain, the images of modern America must have seemed as if they had come from the land of Cockaigne, a legendary world of abundance, a pleasure palace where one's every desire could be fulfilled. Paolozzi showed these collages without commentary in an epidiascope 'lecture' to a largely bemused audience of young artists, critics and intellectuals at a meeting in 1952 of the newly formed Independent Group in London's Institute of Contemporary Arts (ICA). This group was committed to exploring in wide-ranging lectures and discussions the latest ideas and information about technology, industrial design, micro-photography, mathematics, perception, information theory, advertising, fashion, popular music, abstract art etc. Paolozzi's 'Bunk!' lecture,

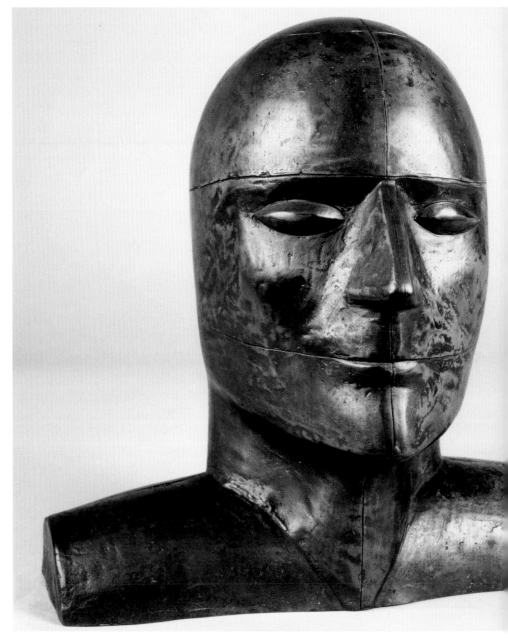

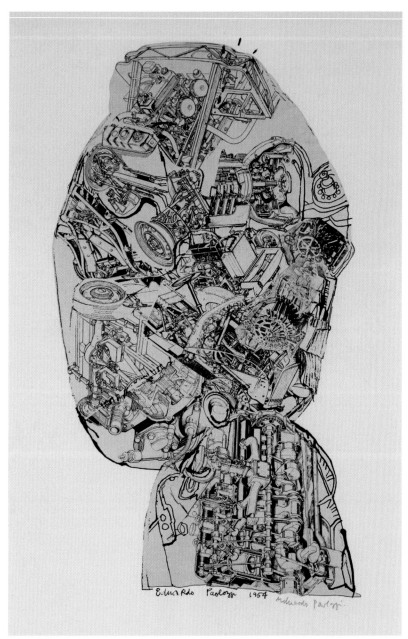

Figure 18
Eduardo Paolozzi (1924–2005)
Mr Cruickshank, 1950 (or 1959)
Bronze, 27 × 28.2 × 20 cm
National Galleries of Scotland; bequeathed by
Gabrielle Keiller, 1995
GMA 4057

Figure 19
Eduardo Paolozzi (1924–2005)
Automobile Head, 1954/62
Screenprint on paper, 61.6 × 41.3 cm
Tate; presented by Rose and Chris Prater through
the Institute of Contemporary Prints, 1975
P04746

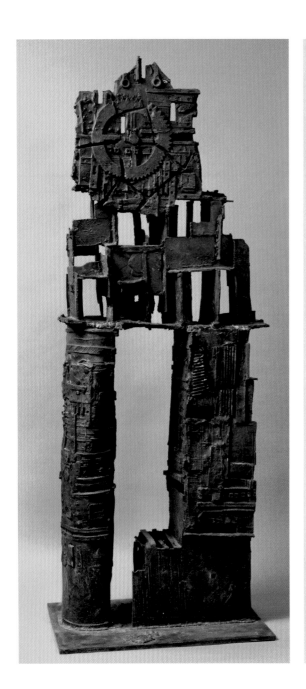

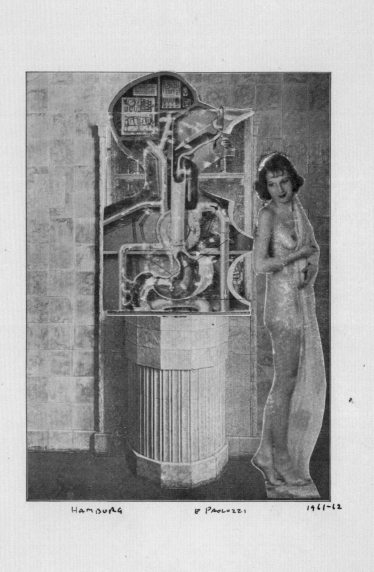

HAMBURG E PAOLOZZI 1961-62

81

as it was called, helped spark an interest in popular culture among several members of the Independent Group and certainly informed the development of the Pop Art movement in Britain. However, it was only one aspect of a general openness to new ideas, many emanating from America. The real driving forces were science and technology which were developing rapidly in the booming economy of the US. Paolozzi's interest in these areas was already apparent, but now – in the company of like-minded young artists, such as Richard Hamilton (1922–2011), Nigel Henderson (1917–1985) and William Turnbull (1922–2012), art historians and theorists, such as Reyner Banham (1922–1988) and Lawrence Alloway (1926–1990), and architects, such as Alison (1928–1993) and Peter (1923–2003) Smithson – it burgeoned and made itself felt in terms of new work and collaborative exhibitions.

What particularly interested Paolozzi was the interface between humans and machines. Machines were the products of human brains, their ingenuity and manual dexterity, but they fed back into people's immediate environment and had an impact on the way that they behaved; and could possibly decide on their ultimate fate. Since the invention of the atomic bomb in 1945 and the dropping of two such bombs on Japan that same year, it was clear that human-built machines could destroy mankind. Paolozzi responded to this dilemma and threat in the sculptures, prints and drawings that he made in the 1950s. The bronze *Mr Cruickshank*, 1950 (or 1959); **(fig.18)** consists of a head based on a magazine image that Paolozzi had seen of a human dummy used by American scientists to test the impact of large doses of X-rays on the human head. In 1954 he made a collage of a human head, *Automobile Head*, the outline of which is filled with engine parts: a crankshaft for the spinal column, aero-engines for the eyes, pistons and cylinders indicating the complex functioning of the brain. This was an image that gripped Paolozzi's imagination. He made one of his first screenprints of the collage in 1962 **(fig.19)**, using the expert knowledge of Chris Prater. He returned to the image much later, in the 1980s, in various etchings, distorting and elongating the head, but still remaining true to his initial idea of a head functioning as a machine.

At about the same time that Paolozzi was making this original collage, he was beginning to experiment with new ways of making bronze figure sculptures that incorporated impressions, both indented (negative) and raised (positive), of machine parts and other items of industrial society's detritus. He did this by pressing these found objects into soft wax or wet plaster. He would then cut the wax with the indented impressions into strips, or pour molten wax into the set plaster (thus obtaining a raised impression) and proceed to cut that wax into strips when hardened. Finally, he would warm and soften the lengths of wax and mould them into a figure, and, by using the lost-wax method of casting, create the finished bronze sculpture **(fig.20)**.

The next major development in Paolozzi's work, and one in which changes in his collages and prints went hand in hand with changes in his sculptures, happened in the early 1960s. Working in Hamburg as a visiting lecturer at the art school, he came across books, illustrating early modernist interiors, in the city's second-hand bookshops. This led to a whole series of Surrealist-inspired collages **(fig.21)** which became the basis for Paolozzi's first film,

The History of Nothing (1961–62). Also in Hamburg he saw piles of metal parts in the dockyards, which gave him the idea of using prefabricated, industrial products to make his sculptures. Instead of casting in bronze, he would have aluminium sections welded together to create a more truly mechanised form of sculpture. When he was back in Britain he began working with a couple of engineering works in East Anglia to make a whole series of robotic figures, skyscraper-like structures and multi-part sculptures (fig.22). He would often choose serial, pre-manufactured parts that he found in the engineering factories; but if he could not find what fitted his purpose, he designed pieces that looked as if they were ready made and had them manufactured to his specifications. The new industrial shapes also began to appear in his works on paper. It was then that, as luck would have it, he came into contact with Chris Prater and found that screenprinting would allow him to control the forms and colours of his prints in a much more mechanised, semi-industrial process. Metalization of a Dream, 1963 (figs 2, 3), which was the first print that he made in this way, showed industrial metal constructions, not unlike some of his new sculptures, sitting in a domestic interior; as previously noted, he was also able to alter the colour combinations of the print in a similar way

to an assembly line that could offer products in a variety of colours.

After he had established a new freedom in exploiting the technical possibilities of screenprinting and, just as important, after the widespread acceptance that screenprinting was an artistically valid and innovative way of reproducing photographic images, Paolozzi entered a phase in his career when making prints was just as important as making sculptures. There followed in the 1960s and 1970s one great set of prints after another, beginning with arguably his masterpiece, As is When, 1965 (fig.23). The basis of this and of all his later screenprints is complex collages of images, geometrical patterns and words; these are then photographed to provide the structure of the prints. The innovative feature was the next step. Because Paolozzi was now able, with the help of the master printmakers he worked with, to manipulate the colours simply by changing the screens, he could make each successive print look different. In addition, by working with a suite of prints, each with a wide variety of images, Paolozzi could create as rich a bank of images as the Internet can provide today – popular culture, the latest technological breakthroughs, the human body (whether conceived medically, sexually or

Figure 22
Eduardo Paolozzi (1924–2005)
The Bishop of Kuban, 1962
Aluminium, 210 × 93 × 60.7 cm
National Galleries of Scotland; purchased 1990
GMA 3566

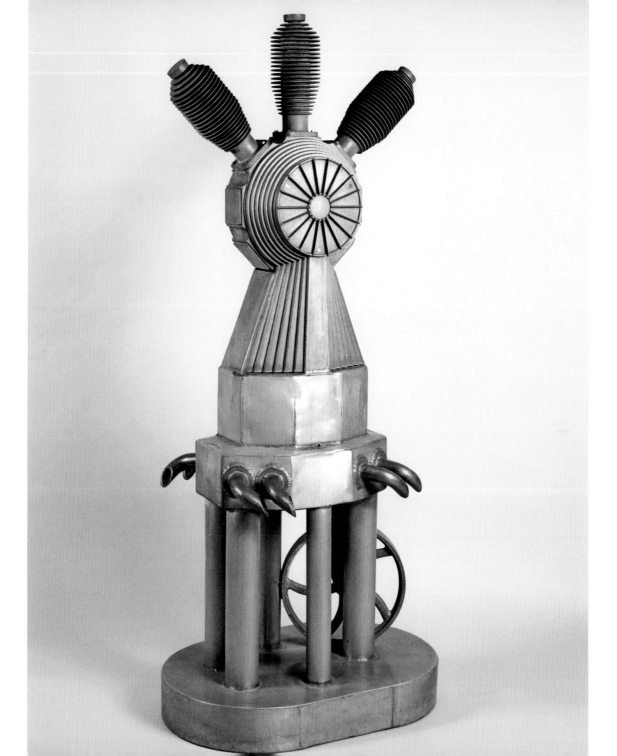

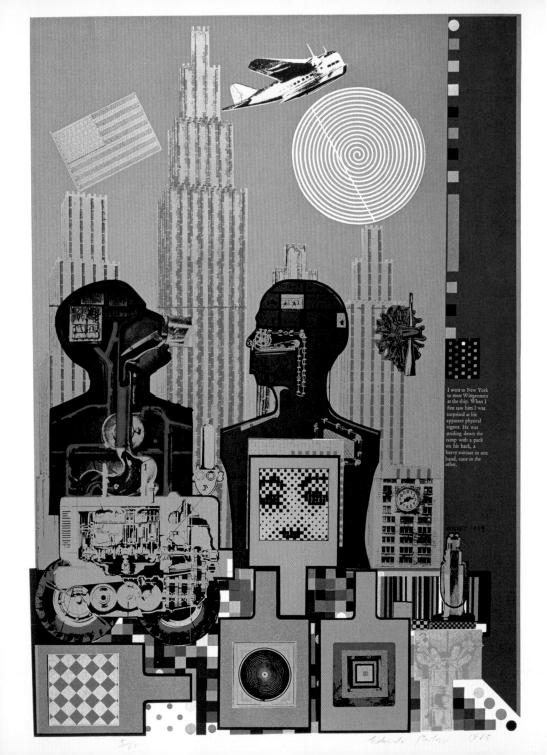

Figure 23
Eduardo Paolozzi (1924–2005)
As is When (*Wittgenstein in New York*), 1965
Part of a portfolio of twelve screenprints, poster and
text on paper, 96 × 66, 83 × 55 cm and smaller,
each print printed with individual colourway
National Galleries of Scotland; purchased 2001
GMA 4366 K

I went to New York
to meet Wittgenstein
at the ship. When I
first saw him I was
surprised at his
apparent physical
vigour. He was
striding down the
ramp with a pack
on his back, a
heavy suitcase in one
hand, cane in the
other.

Figure 24
Eduardo Paolozzi (1924–2005)
Mr Machine [working drawing], c.1971
Pencil on transfer paper
35.5 × 20 cm
National Galleries of Scotland; presented by the
artist, 1995
GMA.A.40.17/6

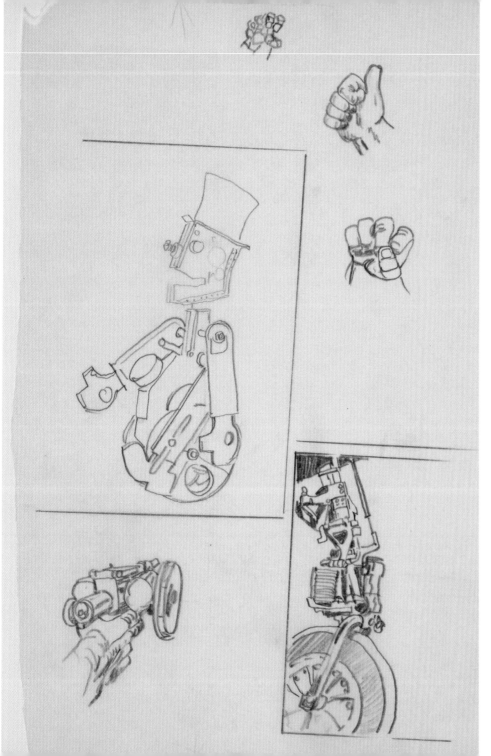

scientifically), science fiction, to name but a few of the subjects dealt with by the artist.

Paolozzi was a voracious consumer of images and information, and his prints from this period give a vivid insight into his mind. His abiding focus, however, was always the machine, both as the engine driving the world forward and the potentially independent robot that might one day take over. In 1971 he made a film with Peter Leake and Keith Griffiths from the Royal College of Art, called *Mr Machine*. It was based on drawings that Paolozzi had made of a robot toy, fabricated in America in the 1960s **(fig.24)**. This animated film and the drawings sum up, in many ways, what most excited Paolozzi about technology: its ability to bring human ideas to life, both metaphorically and literally.

Unlike Paolozzi, Warhol's main interest in the machine was as a psychological and historical paradigm: psychological, because it provided Warhol with a model for dealing with the world at a distance, objectively and with as little visible emotion as possible; historical, because he realised that there was a distinct development in modern art that saw technological and scientific advances as a way of reducing the need for human intervention in art processes to a minimum.

1928 – Born 6 August in Pittsburgh to parents from Ruthenia, an area that is now on the Slovakian border with Ukraine.

1936 – When confined to bed with chorea, a rheumatic illness, Warhol cuts out pictures from film magazines, comics and colouring books. Collects photographs and autographs of film stars.

1945 – Begins studying at the Carnegie Institute of Technology, Pittsburgh, majoring in pictorial design (until 1949). Attends design class of Robert Lepper (1906–1991), who develops the first industrial design degree programme in the USA and is fascinated by the potential role of technology in making art. Warhol becomes interested in the teachings of the Bauhaus, especially the books written by László Moholy-Nagy (1895–1946).

1948 – Works as picture editor of the student magazine, *Cano*. Makes designs using the 'blotted-line' monotype technique, which is to become his characteristic style in the 1950s.

1949 – Moves to New York. Shows examples of his design work to art directors of main glossy magazines. Receives commissions from *Glamour*, *Vogue*, *Seventeen*, *Harper's Bazaar* and other magazines. Works as a window dresser and book illustrator at the same time.

1952 – First solo exhibition, *Fifteen Drawings Based on the Writings of Truman Capote*, in Hugo Gallery, New York. His mother, Julia Warhola, moves to New York and lives with him for the next twenty years. She often signs his artworks and writes texts for his prints. Develops the 'blotted-line' technique into an offset printing process. Begins producing promotional books as gifts for clients, together with Ralph Thomas Ward ('Corkie'): *Love is a Pink Cake* (1952), *There was Snow on the Street and Rain in the Sky* (1952) and *A is an Alphabet* (1953).

1953 – Joins a theatre group ('Theater 12') and becomes fascinated by the alienation techniques of Bertolt Brecht (1898–1956).

1954 – Produces *25 Cats Name[d] Sam and One Blue Pussy* as a promotional book, together with Charles Lisanby who writes the text. The illustrations are hand-coloured by friends at the fashionable New York café Serendipity.

1955 – Publishes the promotional book *À la recherche du shoe perdu* (texts by Ralph Pomeroy). Designs adverts for the I. Miller shoe company, which regularly feature in the *New York Times*. Hires Vito Giallo and Nathan Gluck as assistants.

1957 – Establishes 'Andy Warhol Enterprises, Inc.'. He is now one of the most successful commercial artists in New York. Publishes the promotional book *A Gold Book*.

1959 – Publishes his last promotional book, *Wild Raspberries* (with Suzie Frankfurt).

1960 – Gets to know the future documentary filmmaker Emile de Antonio. Warhol later says of de Antonio: 'Everything I learned about painting, I learned from De.' Makes his first pictures, of comic-strip figures and later of newspaper adverts for everyday products. All are hand-painted.

1961 – Sees comic-strip paintings by Roy Lichtenstein (1923–1997). Decides to paint no more comic-strip works to avoid overt comparisons. Includes his own paintings in a window display for New York department store Bonwit Teller. Encouraged by friends to paint things that everyone knows, such as money and cans of soup, Warhol heeds the advice and begins to paint pictures of Campbell's soup cans in late 1961 and dollar bills in 1962.

1962 – The soup-can paintings are based on copies of projected photos, from which stencils and rubber stamps are created. Pictures of dollar bills and various adhesive stamps (such as Green Stamps) are made using rubber stamps, although Warhol is already experimenting with screenprinting at the time. It is only with paintings such as *Baseball*, 1962, and heads of young Hollywood stars, such as Natalie Wood and Warren Beatty, that Warhol eventually makes true photo-screenprints. Warhol paints what are later to be called his *Disaster* pictures. Has an exhibition at Ferus Gallery, Los Angeles of thirty-two *Campbell's Soup Can* paintings. After Marilyn Monroe's suicide, Warhol makes a number of paintings based on a film still from *Niagara* (1953). Solo exhibition at Stable Gallery, New York includes Marilyn and Elvis portraits and Coca-Cola painting. Looking back on this crucial period of his work, Warhol says: 'In August '62 I started doing screenprints. The rubber-stamp method I'd been using to repeat images suddenly seemed too homemade. I wanted something stronger that gave more of an assembly line effect' (Andy Warhol and Pat Hackett, *POPism: The Warhol Sixties*, New York, 1980).

1963 – Paints *Electric Chair* and *Race Riot* works. After President Kennedy's assassination on 22 November, Warhol works on portraits of Jackie Kennedy. Makes his first film, *Sleep*, showing his friend John Giorno sleeping. The film, lasting for over five hours, seems to consist of one extended stationary shot, but is, in fact, more complicated, with multiple repetitions. Meets Jonas Mekas, who sets up the Film-Makers' Cooperative in New York in the same year. Mikas shows several of Warhol's films at the Cooperative. Warhol is an avid viewer of avant-garde films. Makes use of a photobooth for the first time to photograph Ethel Scull for the painting *Ethel Scull Thirty-Six Times*. In an important interview with Gene R. Swenson in *ARTnews* (November) Warhol makes the key statement: 'the reason I am painting this way is that I want to be a machine, and I feel that whatever I do and do machine-like is what I want to do'. June,

rents a studio in a former fire station on East 87th Street, which becomes the first 'Factory'. Hires Gerard Malanga as an assistant. He stays with Warhol until 1970. *Elvis* portraits shown at Ferus Gallery. Goes to the opening and meets Marcel Duchamp (1887–1968), one of his heroes, at the latter's retrospective in Pasadena. November, the 'Factory' moves to a loft on East 47th Street, the 'Silver Factory', so-called because the walls are covered with aluminium foil and silver paint.

1964 – Commissioned to make a mural for the New York State Pavilion at the New York World's Fair. Makes portraits of *Thirteen Most Wanted Men*. The authorities find it unacceptable. Warhol has it covered over with silver paint. Makes *Empire*, a static, single-shot film lasting twenty-four hours, of Empire State Building. Shoots first 'screen tests' using friends, acquaintances and casual visitors to the Factory. *Disaster* paintings shown to great acclaim in Paris. Exhibition of *Brillo Boxes, Campbell's Soup Cans* and *Heinz Boxes* at Stable Gallery. Little sells. Moves to Leo Castelli Gallery. *Flowers* exhibition shown at Castelli Gallery. Everything sells. Acquires a tape recorder which he carries with him at all times, recording conversations. The Factory becomes a meeting place for artists, celebrities and hangers-on.

1965 – Meets Paul Morrissey who makes all of 'Warhol's' films in future. Members of the Velvet Underground are frequent visitors to the Factory. Announces that he is giving up painting to concentrate on films. Retrospective at Institute of Contemporary Art, Philadelphia.

1966 – Produces multimedia events, later called 'The Exploding Plastic Inevitable', with the Velvet Underground. Shows *Silver Clouds* (silver, helium-filled balloons) and *Cow Wallpaper* at Castelli Gallery. His film *The Chelsea Girls* is well received.

1967 – Meets Fred Hughes who becomes his business manager. *Andy Warhol's Index (Book)* and *Screen Tests: A Diary* (produced with Gerard Malanga) published. Makes *Marilyn*, a portfolio of ten screenprints.

1968 – February, the Factory moves to 33 Union Square West. First European retrospective at Moderna Museet, Stockholm. Warhol designs the catalogue. *A: A Novel* is published. Makes the films *Blue Movie* and *Flesh* (with Paul Morrissey). Warhol is shot in the Factory by Valerie Solanas, the founder of SCUM (Society for Cutting Up Men); he is seriously wounded. June–September, *Marilyn* set of prints (fig.4) included in exhibition *Five Artists at the Four Seasons*, organised by MoMA, at the Four Seasons Restaurant, New York; also features works by Eduardo Paolozzi.

1969 – First issue of *Interview* magazine, edited by Warhol, Malanga and others. Meets Vincent Fremont, who later becomes Warhol's studio manager and vice-president of Andy Warhol Enterprises, Inc.

1970 – Retrospective at Pasadena Art Museum, California; tour includes Tate Gallery and Whitney Museum of American Art, New York. First monograph on Warhol (by Rainer Crone) published.

1971 – Designs cover for Rolling Stones record album *Sticky Fingers*.

1972 – Makes portrait poster of Richard Nixon with the tag line 'Vote McGovern'. Begins to dictate diary to Pat Hackett – used as basis of book published after his death. Begins series of *Mao* paintings which he treats in a very painterly manner, ushering in a new way of working. Starts making portraits of friends based on Polaroid photographs. This eventually leads to celebrity and commissioned portraits.

1974 – Begins putting his accumulated archive into *Time Capsules* for storage and possible future display. The Factory moves to 860 Broadway.

1975 – *The Philosophy of Andy Warhol (From A to B and Back Again)*, with Pat Hackett, is published.

1977 – Paints *Hammer and Sickle* series.

1978 – Makes *Oxidation* and *Shadow* pictures.

1979 – *Andy Warhol's Exposures* is published.

1980 – *POPism: The Warhol Sixties* by Warhol and Pat Hackett is published. *Andy Warhol's TV*, a cable talk show, begins.

1983 – Warhol and Jean-Michel Basquiat (1960–1988) become friends and paint collaborative pictures.

1984 – Moves his studio and offices to East 33rd Street.

1985 – Paints *Ads* pictures. *America*, a collection of photographs taken by Warhol, is published.

1986 – Paints *Camouflage* and *Self-portraits* works. Creates 'stitched photographs'.

1987 – Dies unexpectedly on 22 February after complications following a routine operation.

1924 – Born 7 March in Leith (Edinburgh). His parents (both born in Italy) have a confectioner's shop. Spends his summers as a boy in a youth camp on the Adriatic coast of Italy, run by the Italian Fascist Party.

1940 – All male members of the Paolozzi family are arrested under the Enemy Aliens Act. Paolozzi is interned in Saughton prison, Edinburgh. His father, grandfather and others are sent for transportation to Canada. The ship they are on, the SS *Arandora Star*, is torpedoed and all his male relatives are killed. Paolozzi is released from prison and he, his mother and sister return home and to the shop.

1941–42 – Attends evening classes at Edinburgh College of Art which are geared to crafts rather than fine art. He considers becoming a commercial artist.

1943 – Studies full-time at Edinburgh College of Art. June, called up in the army. Stationed near Buxton, where, in the public library, he finds a copy of Amédée Ozenfant's *The Foundations of Modern Art* (1931), which embraces technology and the machine and gives them a classical, timeless quality.

1944 – Paolozzi is discharged from the army after failing a medical examination. Studies at the Ruskin Drawing School in Oxford, where the Slade School of Fine Art, University of London has been relocated during the War. Creates a scrapbook which he intends to 'relive Ozenfant'.

1945 – April, transfers to the Slade in London. Studies sculpture and drawing. Makes friends with fellow students William Turnbull (1922–2012) and Nigel Henderson (1917–1985), who owns a copy of *The Green Box* by Marcel Duchamp (1887–1968), a collection of facsimile notes explaining some of the ideas behind his mechanomorphic masterpiece, *The Bride Stripped Bare by her Bachelors, Even* (*The Large Glass*), 1915–23. Meets Roland Penrose, whose collection of works by Pablo Picasso (1881–1973), the Dada artists and the Surrealists he gets to know well.

1946 – Makes sculptures modelled in concrete and collages of ancient sculptures and mechanical parts.

1947 – Solo exhibition at Mayor Gallery, London. Works sold in the show enable him to move to Paris, without taking his Diploma from the Slade. Together with Nigel Henderson visits Fernand Léger (1881–1955), who organises a showing of his film *Ballet Mécanique*, 1924. He also meets Jean Arp (1886–1966), Balthus (1908–2001), Constantin Brancusi (1876–1957), Georges Braque (1882–1963), Jean Dubuffet (1901–1985) and Tristan Tzara (1896–1963). Duchamp's lover Mary Reynolds shows him the works she has by Duchamp in her apartment. Of all the artists he meets in Paris, he sees Alberto Giacometti (1901–1966) the most: 'he was the one I admired most … the one that was intellectually and physically the most approachable.'

1948 – Makes relief sculptures of insects and marine life; discovers the book *On Growth and Form* (1917) by D'Arcy Wentworth Thompson (1860–1948), which has a major impact on his sculptures and prints.

1949 – October, returns to London. Teaches textile design at the Central School of Art (until 1955), where he makes his first screenprints with Anton Ehrenzweig (1908–1966).

1950 – Meets the architects Jane Drew (1911–1996) and Maxwell Fry (1899–1987). Asked by Drew to decorate the bar for London's new Institute of Contemporary Arts (ICA).

1951 – Makes *Fountain* for Festival of Britain exhibition on South Bank, London.

1952 – At the first meeting of the 'Young', later Independent Group at the ICA, gives his famous 'Bunk!' lecture, using collages and tear sheets of adverts and popular imagery (nearly all from American magazines), projected using an epidiascope and without commentary. Makes ceiling design for an office in premises of the design and engineering firm Ove Arup in London; and a large collaged mural for Fry, Drew and Partners. Takes part in exhibition *New Aspects of British Sculpture* in the British Pavilion at the Venice Biennale.

1953 – Finalist in sculpture competition for *Unknown Political Prisoner*. Exhibition *Parallel of Life and Art*, organised by Paolozzi, Henderson and the architects Alison (1928–1993) and Peter (1923–2003) Smithson at the ICA.

1954 – In a self-built foundry in the garden of ICA director Dorothy Morland's house in Hampstead, and with the help of her son, begins to cast bronze sculptures. Hammer Prints set up by Paolozzi and Nigel and Judith Henderson, a commercial venture to make and sell ceramics, textiles, wallpaper and furniture. Makes iconic collage *Automobile Head*.

1955 – Begins teaching sculpture part-time at St Martin's School of Art (until 1958).

1956 – Takes part in groundbreaking exhibition *This is Tomorrow* at Whitechapel Art Gallery: Group 6 'Patio and Pavilion', created by Paolozzi, Henderson and Alison and Peter Smithson. Begins to impress found objects, many of them machine parts, into soft wax, in order to create a machine-encrusted surface to his bronzes (fig.20).

1958 – Included in *Seven Sculptors: Sculpture and Drawings*, Solomon R. Guggenheim Museum, New York. The Guggenheim Museum acquires *St Sebastian, No.2*. Gives a lecture, 'The metamorphosis of rubbish', on his sculpture at the ICA.

1959 – Shows four bronzes in exhibition *New Images of Man* at Museum of Modern Art (MoMA), New York. MoMA buys the bronze *Jason*.

1960 – Exhibition of twelve bronzes in solo show at Betty Parsons Gallery, New York. Sees *Homage to New York* by Jean Tinguely (1925–1991) at MoMA.

Exhibition of twenty-two bronzes, dating from 1956–58, at Venice Biennale's *Sculpture Today*. Is awarded David E. Bright Foundation Award for Best Sculptor under Forty-Five. Autumn, appointed advisor on sculpture and design at University of Fine Arts, Hamburg; teaches a course on Radical Surrealism, which he calls 'The Translation of Experience'. Meets Gabrielle Keiller who becomes his most important patron.

1961 – Creates designs for sculptures in various metals to be made by Thackerays and Sons, Engineers in Suffolk. Begins working with C.W. Juby's 'Alpha' Engineering Works, Ipswich to make sculptures in aluminium; collaboration lasts over ten years. *Collage*, 1953 now in the collection of the National Galleries of Scotland shown in the exhibition *The Art of Assemblage* at MoMA, New York.

1962 – Solo exhibition at Betty Parsons Gallery (seventeen sculptures). Begins collaborating with Chris Prater of Kelpra Studio on making screenprints. Makes screenprints of two key early collages: *Automobile Head*, 1954 (fig.19) and *Standing Figure*, 1956–58. Starts to make welded and bolted aluminium sculptures. Collaborates with R.B. Kitaj (1932–2007) on two assemblage works. Makes film *History of Nothing*, based on collages created in Hamburg. Publishes screenprinted book *Metafisikal Translations* together with Kelpra Studio.

1963 – Collaborating with Chris Prater, makes the breakthrough screenprint *Metalization of a Dream* (figs 2, 3), in which each of the forty editioned prints has a different colour combination. Also publishes the book of the same title, with a text by Lawrence Alloway.

1964 – Shows two sculptures at *documenta III*. Begins painting his sculptures. Solo show at Robert Fraser Gallery, London with five aluminium sculptures and collages for the *As is When* set of screenprints, and solo show at MoMA with four sculptures and the first four *As is When* screenprints.

1965 – Silkscreen portfolio *As is When* published by Editions Alecto, London. Makes the film *Kakafon Kakkoon*, based on the images in *As is When* (fig.23).

1966 – Solo show of recent sculpture, including chrome-plated steel works, at Pace Gallery, New York. The book *Kex*, compiled for Paolozzi by Richard Hamilton (1922–2011), published.

1967 – Writes letter to *The Guardian* defending screenprints as fine and not commercial art. Wins first prize for sculpture at the Carnegie International Exhibition of Contemporary Paintings and Sculpture in Pittsburgh.

1968 – Solo exhibition at the Scottish National Gallery of Modern Art. Visiting Lecturer at the University of California, Berkeley. Makes proposals for computer-generated imagery for the *Art and Technology* project, planned for spring 1970 at the Los Angeles County Museum of Art. Begins to teach part-time (until 1989) in the ceramics department at the Royal College of Art. June–September, included in exhibition *Five Artists at the Four Seasons*, organised by MoMA, at the Four Seasons Restaurant, New York; also features works by Andy Warhol.

1969 – Resigns as director of Hammer Prints. Works on *Art and Technology* project in California.

1970 – First substantial monograph published, by American academic Diane Kirkpatrick.

1971 – Retrospective exhibition at Tate Gallery, London.

1972 – Publishes *BUNK!*, set of forty-seven facsimile screenprints of the collages shown in the 1952 ICA lecture.

1974 – On DAAD (German Academic Exchange Service) scholarship in Berlin (until 1975).

1975 – Commissioned by Glasgow University to make doors for new Hunterian Art Gallery.

1977 – Exhibition of his complete prints at Victoria and Albert Museum, London. Appointed Professor of Ceramics at Cologne University of Applied Sciences (to 1981).

1980 – Commissioned to make mosaics for Tottenham Court Road Tube Station (finished 1986).

1981 – Appointed Professor of Sculpture at Munich Academy of Fine Arts (to 1991); holds masterclasses in the Glyptothek, drawing from the antique sculptures; leads to re-introduction of the human figure in his sculpture.

1984 – Exhibition *Eduardo Paolozzi: Recurring Themes*, Royal Scottish Academy, Edinburgh.

1985 – Exhibition *Lost Magic Kingdoms*, Museum of Mankind, London and tour. 'The Krazy Kat Arkive' bought by Victoria and Albert Museum.

1988 – Begins making sculpture *The Manuscript of Monte Cassino* for Picardy Place, Edinburgh (installed 1991).

1989 – Appointed Visiting Professor at Royal College of Art, London.

1990 – Exhibition *The Independent Group: Postwar Britain and the Aesthetics of Plenty*, ICA, London and tour.

1992 – Commissioned to make *Newton after Blake* for the new British Library (installed 1997) and *The Wealth of Nations* for the Royal Bank of Scotland, Edinburgh (installed 1993).

1995 – Commissioned to make large indoor sculpture, *Vulcan*, for the new Dean Gallery (now Modern Two), National Galleries of Scotland (installed 1999).

1999 – Opening of Dean Gallery, which, as well as sculpture of *Vulcan*, contains installation of his studio.

2005 – Dies 22 April in London.

ENDNOTES

1. *Five Artists at the Four Seasons*, 28 June – September 1968. The other artists featured were Martin Canin (American, born 1927), Henry Pearson (American, 1914–2006) and Michelangelo Pistoletto (Italian, born 1933).

2. Portfolio of ten screenprints on paper, edition of 250, printed by Aetna Silkscreen Products, Inc., New York; published by Factory Editions, New York.

3. Eduardo Paolozzi, *Universal Electronic Vacuum*, 1967; portfolio of ten sheets, one poster and text, screenprint, 101.5 × 68.5 cm / 91 × 61 cm; edition of seventy-five and fifteen artist's proofs; each sheet printed in individual colourway; printed by Kelpra Studios, London; published by Eduardo Paolozzi; distributed by Editions Alecto London, Hanover Gallery, London and Pace Gallery, New York. The two prints exhibited at the Four Seasons restaurant were *A Formula that can Shatter into a Million Glass Bullets* and *Computer-Epoch*.

4. Andy Warhol in Gene R. Swenson, '"What is Pop Art?" Interviews with eight painters (Part 1)', *ARTnews*, November 1963.

5. Herbert Bayer, Walter Gropius and Ise Gropius (eds), *Bauhaus, 1919–1928*, exhibition catalogue, Museum of Modern Art, New York, 1938; *Machine Art*, exhibition catalogue, Museum of Modern Art, New York, 1934.

6. László Moholy-Nagy, *Painting, Photography, Film*, translated by Janet Seligman, London, 1969, p.15. The use of bold print to emphasise certain words dates back to Moholy-Nagy's original German edition of 1925. This English translation of Moholy-Nagy's famous Bauhaus book could not have been read by Warhol, but his tutor Robert Lepper, who had German parents, may have helped him with a translation, and two of his other books – *The New Vision: Fundamentals of Design, Painting, Sculpture, Architecture*, translated by Daphne Hoffman, New York, 1938 and *Vision in Motion*, Chicago, 1947 – would have been readily available to him in Pittsburgh. In her book *Moholy-Nagy: Experiment in Totality* (New York, 1950), the artist's widow Sybil Moholy-Nagy translates a key, relevant passage from her husband's book *Painting, Photography, Film*.

7. Corkie [alias of Ralph T. Ward] and Andy Warhol, *A is an Alphabet*, [1953], twenty-six offset prints in waxed paper cover, each 24.2 × 15.3 cm, print run of c.100.

8. László Moholy-Nagy, *Painting, Photography, Film*, translated by Janet Seligman, London, 1969, p.15.

Published by the Trustees of the National Galleries of Scotland to accompany the exhibition *Andy Warhol and Eduardo Paolozzi: I Want to Be a Machine* held at the Scottish National Gallery of Modern Art, Edinburgh, from 17 November 2018 to 02 June 2019.

Not all the works illustrated in the catalogue will be included in the exhibition.

ISBN 978 1 911054 30 6

Printed in Belgium on Perigord 150gsm by Die Keure
Designed and typeset by Caleb Rutherford e i d e t i c

Front cover: Andy Warhol, *The Shadow*, 1981 (detail of fig.12)

Title page: Eduardo Paolozzi, *Athena Lemnia von Phidias*, 1953 (detail of fig.15)

Back cover: Eduardo Paolozzi, *Mr Machine* [working drawing], c.1971 (detail of fig.24)

This exhibition has been made possible with the assistance of the Government Indemnity Scheme provided by Scottish Government.

National Galleries of Scotland is a charity registered in Scotland (no.SC003728).

Copyright and Photographic Credits

NATIONAL GALLERIES SCOTLAND

FSC MIX Paper from responsible sources FSC® C009115